Everyone has a different name for their grandmother- granny, grans, or nanna are but a few.

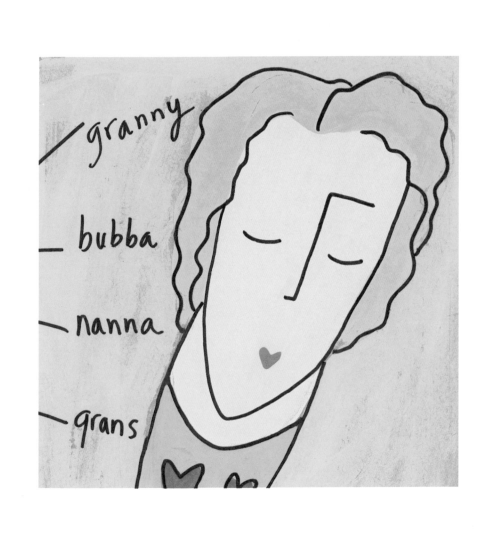

But, I'll call you
Love because it's
what you are
made of
through and through.

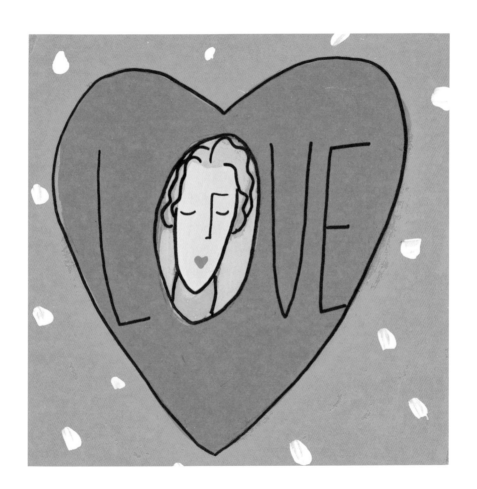

*L*
is for the way
you

laugh and play...

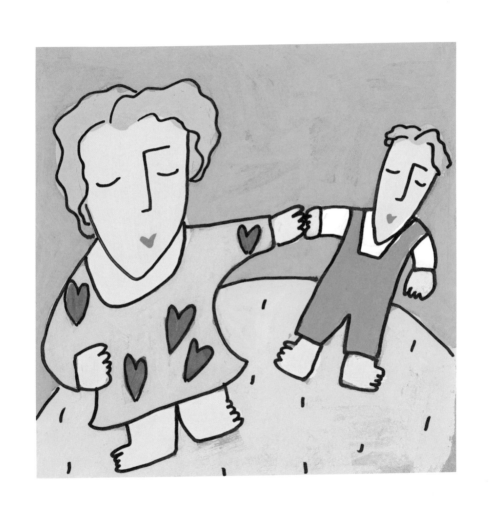

for the
memories
and stories
you share in
your loving
way.

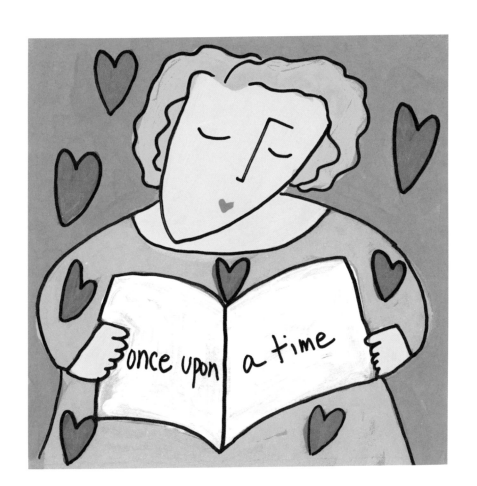

O

because you
are an original,
a one of a
Kind.

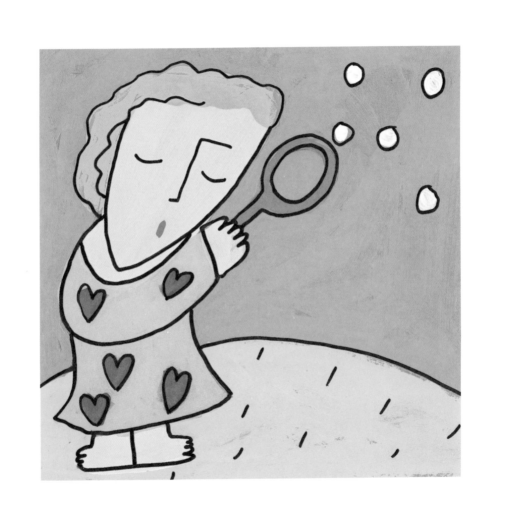

You fill
every minute
with
magic—

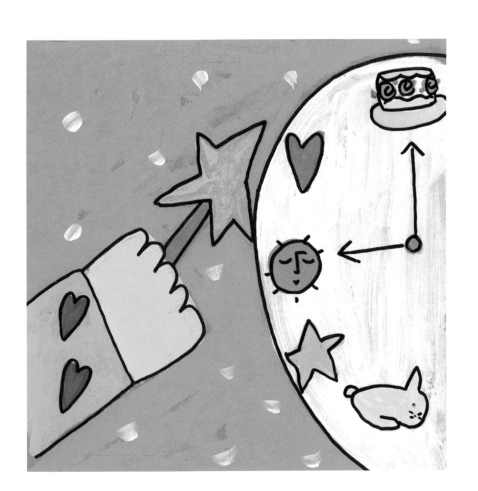

each day
with you feels
like a precious
gift that's
all mine.

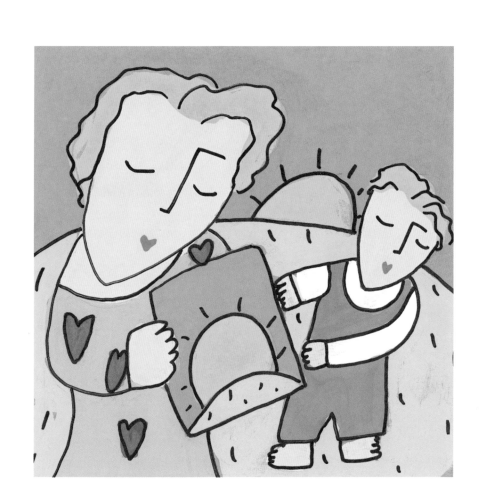

V
is because you
are very special
in every
way.

Your hugs
make me feel
safe and loved,
reminding me
that everything
is okay.

You are
full
of surprises
and treats.

You know
how I
love
sweets!

E
Says you are
extraordinary,
like the
evening
star.

You fill my world with light, and I know you are there even when you're very far.

You are everything a grandmother should be — thoughtful, patient, and kind.

I love you
and I am
so glad
you're mine.